anarchy

anar

chy

John Cage

NEW YORK CITY—JANUARY 1988

Wesleyan University Press Middletown, Connecticut

Wesleyan University Press
© 1988 John Cage
First Wesleyan edition 2001
All rights reserved

ISBN 0-8195-6466-4
Printed in Barcelona, Spain
Design by Richard Hendel
Set in Monotype Garamond by
B. Williams & Associates

CIP data appear at the end of the book

In order to write *Themes and Variations* I made a cursory examination of my earlier books, jotting down subjects or ideas which still seemed lively to me. When I counted them up they came to one hundred and ten. Anarchy is one of them. The themes of *Themes and Variations* are the named of fifteen of the men who have been most important to me in my life and work. Buckminster Fuller is one of them. From the beginning of my knowing him I had as he did confidence in his plan to make life on earth a success for everyone. His plan is to make an equation between human needs and world resources. I had the good luck in Hawaii to see proof of the viability of Fuller's plan. The island of Oahu is divided by a mountain range. Honolulu is on the southern side. I was staying with friends on the northern side. The mountain range is of course tunnelled. But at its ridge I noticed each day crenelations as on a medieval castle. What are those, I asked. I was told that formerly, actually not so long ago, the tribes on one side of the mountain were at war with those on the other side. The crenelations were used for self-protection when shooting poisoned arrows at enemies. Now the tunnel exists and both sides of the island share the same utilities. The idea of fighting one another is out of the question. This change was not brought about by a political agreement. Buckminster Fuller believed, and I follow him, that politicians are of no good use. They could be sent as he used to say to outer space and left there without matters getting worse for humanity here on earth. We don't need government. We need utilities: air, water, energy, travel and communication means, food and shelter. We have no need for imaginary mountain ranges between separate nations. We can make tunnels through the real ones. Nor do we have any need for the continuing division of people into those who have what they need and those who don't. Both Fuller and Marshall McLuhan knew, furthermore, that work is now obsolete. We have invented machines to do it for us. Now that we have no need to do anything what shall we do? Looking at Fuller's Geodesic World Map we see that the earth is a single island. Oahu. We must give all the people all they need to live in any way they wish. Our present laws protect the rich from the poor. If there are to be laws we need ones that begin with the acceptance of poverty as a way of life. We must make the earth safe for poverty without dependence on government.

That government is best which governs not at all; and when men are prepared for it, that will be the kind of government which they will have. That quotation from Henry David Thoreau's *Essay on the Duty of Civil Disobedience* is one of thirty quotations from which as maximum source the following lecture was written. The lecture consists of twenty fifty per cent mesostics. In a fifty per cent mesostic the second letter of the string does not appear between itself and the first letter. In a one hundred per cent mesostic neither the first nor the second letter appears between the first and second letters. How many and which of the thirty quotations were used as source for each of the twenty mesostics was answered

by IC (a program by Andrew Culver simulating the coin oracle of the *I Ching*). Which is the thirty quotations together with the fourteen names (authors, book titles, graffiti) was to be used as the string upon which each mesostic was written was also determined by IC. Where, through the use of chance operations, duplication of strings resulted, the mesostics having the same string became a single renga, a single poem composed for a plurality of poems. A renga in the text itself is indicated by an asterisk following the mesostic number. A program made by Andrew Culver extended the number of characters in a search string for MESOLIST (a program by Jim Rosenberg) to any length; this extended MESOLIST was used to list the available words which were then subjected to IC. The resultant mesostics are therefore global with respect to their sources, coming as they do from anywhere in them. In seven cases, for one or more letters of the string there were no words.

This is another text in an ongoing series; *Themes and Variations, Mushrooms et Variationes, The First Meeting of the Satie Society* precede it: to find a way of writing which through coming from ideas is not about them; or is not about ideas but produces them. *Anarchy* was written to be read out loud. The ends of stanzas are indicated by space, a full stop, a new breath. Within a stanza, the sign ' indicates a slight pause, a half cadence. My mesostic texts do not make ordinary sense. They make nonsense, which is taught as a serious subject by Yasunari Takahashi, author of a huge book, *Nonsense Taizen* (translatable as *Summa Nonsensica*), whose official title is Professor of English at the University of Tokyo. If nonsense is found intolerable, think of my work as music, which is, Arnold Schoenberg used to say, a question of repetition and variation, variations itself being a form of repetition in which some things are changed and others not. Or think of work, as McLuhan did, as obsolete. Instead of working, to quote McLuhan, we now brush information against information. We are doing everything we can to make new connections.

I am glad that in preparation for this work I read *Living My Life* the two volume autobiography by Emma Goldman. William Buwalda, a soldier of the United States Army, who dared to go to one of Goldman's lectures on anarchy was court-martialed and sentenced to a year in jail. I recommend Goldman's book to all those who like books that are hard to put down once you've picked them up. I am grateful to Sydney Cowell who led me to Paul Avrich who led me to Paul Berman, author of *Quotations from the Anarchists*, to William Anastasi who loaned me Seldes' *Great Quotations*, and I am grateful to Electra Yourke who gave me *The Essential Works of Anarchism* edited by Marshall S. Shatz which she found in a second-hand bookstore in Easthampton on sale for ninety-nine cents. I have read and reread it. And I am grateful to James J. Martin who wrote *Men Against the State*. It is one of those books I never have because I'm always giving them away.

Periods of very slow changes are succeeded by periods of violent changes. Revolutions are as necessary for evolution as the slow changes which prepare them

and succeed them. (Peter Kropotkin, *Revolutionary Studies*, 1892, in Berman, *Quotations*, 95). Alteration of global society through electronics so that world will go round by means of united intelligence rather than by means of divisive intelligence (politics, economics). (John Cage, *A Year From Monday*, 17). The revolution is the creation of new living institutions, new groupings, new social relationships; it is the destruction of privileges and monopolies; it is the new spirit of justice, of brotherhood, of freedom which must renew the whole of social life and raise the moral level and material conditions of the masses by calling on them to provide, through direct and conscious action, for their own futures. Revolution is the organization of all public services by those who work in them in their own interest as well the public's; revolution is the destruction of all coercive ties; it is the autonomy of groups, of communes, of regions; revolution is the free federation brought about by a desire for brotherhood, by individual and collective interests, by the needs of production and defense; revolution is the constitution of innumerable free groupings based on ideas, wishes and tastes of all kinds that exist among the people; revolution is the forming and disbanding of thousands of representative, district, communal, regional, national bodies which, without having any legislative power, serve to make known and coordinate the desires and interests of people near and far and which act through information, advice, and example. (Mario Malatesta, *Pensiero e Volonta*, 1924, in Berman, *Quotations*, 102). Electronic democracy (instantaneous voting on the part of anyone): no government; no sheep. (Cage, AYFM, 52 [with addition of "no government"]). The liberty of man consists solely in this: that he obeys natural laws because he has himself recognized them as such, and not because they have been externally imposed upon him by any extrinsic will whatever, divine or human, collective or individual. (Michael Bakunin, *God and the State*, 1871, in Berman, *Quotations*, 161). I'm an anarchist, same as you when you're telephoning, turning on/off the lights, drinking water. (Cage, AYFM, 53). The important thing is not to stop questioning. Curiosity has its own reason for existing. One cannot help but be in awe when he contemplates the mysteries of eternity, of life, of the marvelous structure of reality. It is enough if one tries merely to comprehend a little of this mystery every day. Never lose a holy curiosity. (Albert Einstein, Personal memoir of William Miller, an editor, *Life*, May 2, 1955). Private prospect of enlightenment's no longer sufficient. Not just self- but social-realization. (Cage, AYFM, 53). U.S. OUT OF CENTRAL AMERICA + MIDDLE EAST + MANHATTAN. (Andrew Culver, graffiti noticed in New York Subway, August 1987). We'll take the mad ones with us, and we know where we're going. Even now, he told me, they sit at the crossroads of African villages regenerating society. Mental hospitals: localization of a resource we've yet to exploit. (Cage, AYFM, 59). The age for the veneration for governments, notwithstanding all the hypnotic influence they employ to maintain their position, is more and more passing away. And it is time for people to understand that governments not only are not necessary, but are harmful and most highly immoral institutions, in which a self-respecting, honest man cannot and must not take part, and the advantages of which he cannot and should not enjoy. And as soon as people clearly understand that, they will naturally cease to take part

in such deeds—that is, cease to give the governments soldiers and money. And as soon as a majority of people ceases to do this the fraud which enslaves people will be abolished. Only in this way can people be freed from slavery. (Leo N. Tolstoy, Address, Swedish Government Congress Peace Conference, 1909, *Saturday Review*, 8/9/58, in Georges Seldes, *The Great Quotations*). American anarchist, 1900, admitting failure, retired to the south of France. Dad's airplane engine, 1918, flew to pieces before it left the ground. Alloys needed to contain the power were still undiscovered. Discover dialectrics for ultra-high voltages (global electrical networks). Change society so differences are refreshing, nothing to do with possessions/power. (Cage, AYFM, 68). I heartily accept the motto, "That government is best which governs least"; and I should like to see it acted up to more rapidly and systematically. Carried out, it finally amounts to this, which also I believe—"That government is best which governs not at all"; and when are prepared for it, that will be the kind of government which they will have." (Henry David Thoreau, *Essay on the Duty of Civil Disobedience*, 1849). Society, not being a process a king sets in motion, becomes an impersonal place understood and made useful so that no matter what each individual does his actions enliven the total picture. Anarchy in a place that works. Society's individualized. (Cage, AYFM, 161). Not songs of loyalty along are these/But songs of insurrection also/For I am the sworn poet of every dauntless rebel the world over/And he going with me leaves peace and routine behind him/And stakes his life to be lost at any moment. (Walt Whitman, *To a Foil'd European Revolutionaire*). We have only one mind (the one we share).

Changing things radically, therefore, is simple. You just change that one mind. Base human nature on allishness. (Cage, AYFM, 158). Anarchists or revolutionists can no more be made than musicians. All that can be done is to plant the seeds of thought. Whether something vital will develop depends largely on the fertility of the human soil, though the quality of the intellectual seed must not be overlooked. (Emma Goldman, Preface, *Anarchism and other Essays*, 1910). We are not arranging things in order (that's the function of the utilities): we are merely facilitating processes so that anything can happen. (Cage, M, 12). In San Francisco, in 1908, Emma Goldman's lecture attracted a soldier of the United States Army, William Buwalda. For daring to attend an Anarchist meeting, the free Republic court-martialed Buwalda and imprisoned him for one year. Thanks to the regenerating power of the new philosophy, the government lost a soldier, but the cause of liberty gained a man. (Hippolyte Havel, *Biographic Sketch of Emma Goldman*, 1910). The problem that confronts us today, and which the nearest future is to solve, is how to be one's self and yet in oneness with others, to feel deeply with all human beings and still retain one's own characteristic qualities. (Emma Goldman, *Anarchism*, quoted in Introduction by Richard Drinnon). . . . capacity audience gave him standing ovation. Commenting on this, Fuller said, "It wasn't for me; I'm only an average man. It was for what I'd been saying: the fact it's possible to make life a success for everyone." (Cage, M, 110). Anarchism, then, really stands for the liberation of the human mind from the dominion of religion; the liberation of the human body from the dominion

of property; liberation from the shackles and restraint of government. Anarchism stands for a social order based on the free grouping of individuals for the purpose of producing real social wealth; an order that will guarantee to every human being free access to the earth and full enjoyment of the necessities of life, according to human desires, tastes, and inclinations. (Emma Goldman, *Anarchism*, 1910). A man . . . draws now, as far as he can, on the natural force *in* him that is no different from what it will be in the new society . . . Merely continuing to exist and act in nature and freedom, a free man wins the victory, establishes the new society. . . . (Paul Goodman, *Drawing the Line*). Not only have all the big corporations become transnational and taken all the former U.S.A. gold and other negotiable assets with them, but they have also left all the world's people locked into their 150 national pens, with those 150 nations blocking the flow of lifeblood metals without which we cannot realize the increasing know-how of all humanity. Very soon the nation-state sovereignties will have to be eliminated or humanity will perish. (R. Buckminster Fuller, *Critical Path*, 1981). Problems of governments are not inclusive enough. We need (we've got them) global problems in order to find global solutions. Problems connected with sounds were insufficient to change the nature of music. We had to conceive of silence in order to open our ears. We need to conceive of anarchy to be able whole-heartedly to do whatever another tells us to. (Cage, *M*, 20). . . . class-one evolution is about to put the U.S.A. out of business through international bankruptcy. . . . nature's way of ridding the planet of the most powerful of yesterday's sovereignties and thereby setting off a chain of 149 additional desovereignizations, . . . removing the most stubborn barrier to the free circulation of the Earth's world-around metals, foods, income energy supplies and people. We are now in a position to get rid of the 150 sovereignties and have a recirculatory, interaccomodative, world-around democratic system. We now have the immediately realizable capability to exercise our often-repeated option to make all the Earth's people physically and economically successful within only a decade by virtue of the already-executed fifty-year critical path of artifacts development which has acquired all the right technology. (R. Buckminster Fuller, *Critical Path*, 1981). What we finally seek to do is to create an environment that works so well we can run wild in it. (Norman O. Brown, quoted in *M*, 213). I am a fanatic lover of liberty, considering it as the unique condition under which intelligence, dignity, and the happiness of men can develop and grow; not that purely formal liberty, conceded, measured, and regulated by the State, an eternal life and which in reality never represents anything but the privilege of the few founded on the slavery of everyone, . . . I mean the only liberty truly worthy of the name, liberty that consists in the full development of all the powers—material, intellectual, and moral—that are latent faculties of each; liberty that recognizes no other restrictions than those outlined for us by the laws of our own individual nature, so that properly speaking, there are no restrictions. . . . I mean that liberty of each individual which, far from halting as at a boundary before the liberty of others, finds there its confirmation and its extension to infinity; the illimitable liberty of each through the liberty of all, liberty by solidarity, liberty in equality; liberty triumphing over brute force and the principle

of authority that was never anything but the force; liberty which, after having overthrown all heavenly and earthly idols, will found and organize a new world, that of human solidarity, on the ruins of all Churches and all States. (Michael Bakunin, quoted by Paul Berman, in *Quotations*, 1871). Government is a tree. Its fruits are people. As people ripen, they drop away from the tree. (H.D. Thoreau, *Essay on the Duty of Civil Disobedience*, quoted by John Cage in *X*, 155). To me anarchism was not a mere theory for a distant future; it was a living influence to free us from inhibitions, internal no less than external, and from the destructive barriers that separate man from man. (Emma Goldman, *Living My Life*, pg. 556, 1931).

I

sPirit of
him for onE

corporaTions
arE
failuRe
Know-how of
aRe
idOls will

free rePublic
each thrOugh
Them in
maKe

I
to me

aNarchism

2

sworn Poet of
libeRty

nOthing to
pieces Before it
sociaL
thE

every huMan being
with uS

peOple as
selF
voltaGes
seek tO do

reVolutionists

soon thE
the maRvelous
with possessioNs/power

the Mad
thE
chaNge
The
iS
A social
democRatic
thE

saN
tOday and which
To
realIze the
oNly one
a plaCe that works

and peopLe
abouT
dad'S
development whIch has
Voting on
all thE
rEal
Natural laws
sOcial order
mUst
Global
tHe

i am the sWorn
thE
but be iN
violEnt
suppliEs
to Do is to
What
flow of lifEblood
goldman's lecture
or indiVidual
sharE

violent chanGes
Of
The
if one Tries

mind base Human

a rEcirculatory
arMy

desovereiGnizations

for uLtra
prOcess
Be done is
thAt
revoLutions are

caPability to
feRtility
cOnceive of anarchy
Before it
emma goLdman's
for Existing
hiM

Structure of
does hIs
coNtemplates the
prOducing
eveRy
executeD
purposE

woRld
wiTh
wOrld

nearest Future

I am
reasoN
to Do whatever another tells us to
rid of the 150 sovereiGnties and have
additionaL
Of

Be one's self
An
fLow

foodS
electrOnic democracy instantaneous
criticaL path

bUwalda
neTworks change
busIness
Of
Not
exiSting
deePly with all
foR
nO
to Be
or individuaL
thE

froM
workS
produCing
demOcratic system
uNdiscovered disċover
aNarchism
total picturE
whiCh has
anarchy To
rEtain
anD
the regenerating poWer of the new
to contaIn
prospecT of
wHat
each individual doeS

Of
bUt be
be lost at aNy moment
the immeDiately realizable
qualitieS
Without which
out of businEss

cRitical path
individualizEd

anarchIsm
self aNd
Society
Upon him
oF
way oF
evolutIon
beCome
transnatIonal

wE
aNd
and sTill

mysTery every day

sOmething
south of franCe
to solve is How to be

f

villAges
exterNally
riGht
sharE
human naTure on
a Holy
systEm we
Never
And
wiTh all
with them bUt
eaRth and full

to put thE
nOt be
leFt the
Meeting the
insUfficient
iS

recognIzed them as
allishness anarChists

army William

anyonE

tHe
A '
golD
The

dOes
franCe
nOt
eNergy supplies and
Curiosity has
in ordEr to
does hIs
reVolutions

thE
fOr '
iF
S

path of artIfacts

reaLity it
thEm
oNe
and whiCh
wE
wIll

meNtal
chain Of
weRe
anD
thEm but they
aRe
The
Of
prOcess

a
caPability
with othErs
to every humaN being
tO do
each individUal does
with otheRs to
thE
hAve also
democRatic
iS

hoW to
thEm
aN anarchist
court-martialEd

wE'll take the
maD ones
iT

enjOyment of the
extrinsiC will
tO
chaNge
Confronts
powEr

afrIcan
eVolution

his lifE
Own reason

not just selF but
curiosity privAte prospect
left the grouNd

insurrection Also
poweRful
problem that Confronts
one mind tHe one we share

alloYs needed
The nearest
sOldier
Buwalda for daring to
of thE
And

Barrier to the
onLy
yEar
We

nature on

allisHness
Of
reLigion

with thEm
Human
awE

A
the woRld over and
necessary for evoluTion as
but bE
then really stanDs
through internationaL
metals foods income energY supplies and people we
The
vOltages
attenD an anarchist meeeting
and Other
We
plant tHe
bAse
wiTh
amErican
indiVidual
insufficiEnt
pRoblems in order to

neArest
oNly

fOr
To
perisH
unitEd
dominion of Religion
songs of loyalTy
yEt
soiL
siLence
thiS mystery every
hUman
Simple you
soldier of The
wOrks
repeateD
tO

3

utilitiEs we
that's
mereLy
mereLy

The utilities
cAn
utilitiEs
we are noT
wE are

Merely
Anything can happen
orDer

that's
facilitating prOcesses so that
happeN
wE are
thingS

We are
that anythIng can
funcTion
Happen

fUnction of
thingS
so thAt
Not
arE merely
facilitatiNg
prOcesses
so We
We are not
tHings
wE
utilitiEs
arE merely
order that's
wE
facilitatinG
Of
happeN

wE
wE are
thiNgs
happeN
sO
We are
anytHing
arE
Things

prOceses
are mereLy
arE
funcTion of

arE
anYthing

.that'S
arrangIng
The
we Are
funcTion of
noT arranging
things in ordEr

that's the
anything Can
aRe
nOt
So
So
aRe

Order
cAn
orDer
So
Not
Anything can
Function
we aRe not
In
funCtion
thAt's
thiNgs
that anythIng can

mereLy
mereLy
cAn
thinGs in
wE

order that'S
wE
thinGs in
wE

thiNgs
arE
pRocesses so
hAppen
noT
caN
that'S
nOt
Can
anythIng
arE

The
that anYthing
arE
iN
The function
Are

mereLy
of tHe
Of
utilitieS

Processes
functIon
noT
Are
mereLy
So
faciLitating
nOt
funCtion
thAt
are mereLy
functIon of
cAn
The
arrangIng things
Of
iN
Order

 that's
 Function
 thAt's
 happEn
 that'S
 Of
 Utilities
 meRely

anything Can
 happEn
 happEn

 that's
 arE not
 anYthing
 arE

 noT
 The
 nOt
 thE
 Processes
 mereLy
 Order
 In order
 anyThing

4

destrUction of all coercive
forming and diSbanding
fOrce

liberty

to the earth and fUll

The
allOys needed to contain the power were
halting as at a boundary beFore the liberty of others

individual whiCh

thE
there are No

The
foR '
chAnge
wiLd

of individuAls
and froM
of all thE
foR

lIberty of
eaCh through the liberty of
And

Make
beIng free

access to
the necessities of life accorDing to
all human beings

anD

and earthLy
rEvolution is
onE's self
And which the
power

Serve
liberTy of each
creative an environMent
discover diAlectrics
ruN wild in
tHe

eternAl
Today and
The privilege of
fAilure
at a bouNdary before the

5

buT songs
of Human
takE
plAnet
thinGs
and imprisonEd
oF each

man cannOt and must not take
less than exteRnal
sTill undiscovered
in Him

planEt
of each indiVidual which
it as thE
fraNcisco
thE
Republic
Are
They have also
future It was

must nOt be
brute force aNd the
circulation oF
On this
body fRom the dominion of
sonGs

regenerating sOciety
reVolutionists
statEs
viRtue
aN average
Must
arE
develop aNd
To
anarchiSm

the slavery of everyoNe i mean
 becOmes an impersonal place
 of The necessities of life
more and more passing aWay and
 was for what I'd been saying
 naTural force
 imprisoned Him

 economicS
 make all The
 mAke life a
 No more be
 worlD

 lIfe
 aNd succeed them
 Governments
 Are succeeded by periods of
 actions enLiven the
 for us by the Laws of our own

 naTurally
 Human
 wE are
 properly speaking tHere are no restrictions
 i'm onlY
 in Part
 eterNal
 fOr a
 know-how of all humaniTy very soon
 unIted
 all the right teChnology

 energy supplIes
 caN develop and grow
 the liberation oF
 peopLe
 a tree its frUit

 vEry
 Name
 of artifaCts
 what Each individual does

puT
Humanity
and rEstraint of government
radicallY
to plant thE seeds of
aM a
Process
a goLdman's
it was fOr
libertY

The
pOwer society not being
Mind
Alone
each lIberty
eNslaves

Them
Are as
of everyone I
oN

addiTional
eacH
lifE
mInd
as faR as he can
to Pieces
largely On the
to free uS
sets In
worThy of the

wasn't for me I'm
regenerating sOciety
so that No matter what each
In order
be loSt at any
Metals
frOm the dominion
fRom halting
changEs
A
sovereigNties
crossroaDs

the slavery of everyone i Mean the
grOund
dialectRics
of lifE according to
Periods of
we finAlly
to pieceS
the nation-State
wIll be
lateNt
liberty that recoGnizes
metAls foods income energy supplies and people

We
with All
dignitY
A social order based
iN the new society
will Develop
to do Is
from The
expressIon of that
ceaSe

lefT
dIfferent
huMan
rEvolutionists
increasing know-how oF
is tO
anaRchists

critical Path
hE can
glObal
Powers
evoLution is
futurE

They
peOple as
in sUch deeds

far from haltiNg
he tolD
thE
victoRy
becomeS an
To
A
Now
Do

us from inhibiTions
force in Him
And
hospiTals localization of a resource we've
all the riGht
wOrthy
eVolution as
Evolution is

ultRa high voltages
settiNg off a
freedoM a
arE
caN
which The
changeS which
over aNd
each impersOnal
The

a sOcial order
a chaiN of
successfuL
capacitY
thAt consists in the full development
dRaws
in a position to gEt rid of
gaiNed
Of all
maTerial

aNarchism stands

now havE
men Can
all thE
politicS
dad'S
thAn
Revolutionists
with them but theY have also left
property liBeration
individUalized
Thereby setting off
humAn
libeRation from
uniquE condition under
we'll take tHe
desovereignizAtions
soveReignties will have to be

world-around deMocratic
Fact
yoU just change that
fLow of
theory for A
Not necessary
orDer
soMething vital will
tO
Self
iT
perisH
sets In motion

an averaGe man
tHe
additionaL
majoritY

goIng even now he told
they eMploy to
anarchisM then

Of
Revolutionists
An
onLy
wIll
be doNe

made uSeful so
The new
expressIon of
high volTages
which has acqUired all
To do
to exploIt
needed tO
iNto their 150 national
So that world
to do wIth
aNd as
feW
tHey
get rId of the 150 sovereignties

 Commenting on
 are tHese
 necessAry for
 one'S
 nEtworks
 ridding the pLanet
 Facilitating
 theiR
 mE
 Such deeds

business through international banktuPtcy
 thE ground alloys needed
 that is Cease
 to The south
 of all humanIty
 a bouNdary before the liberty of others finds there its
 Gave

 be in tHe new
 the new sOciety
 that they will Naturally
 ridding thE planet of the
 alSo
 songs of loyalTy alone are these but songs of
 governMents

 the right technology whAt
 other Negotiable assets with them but
 faCulties of
 metAls
 elimiNated or
 motioN
 based On
 To the
 As
 oN
 Do with
 Money
 groUping

 fuller Said
 To do with
 it i am a faNatic
 tO do
 will naTurally
 full developmenT of
 Are

a process a King
rid of thE
all the hyPnotic influence
gold And
Real social
inclinaTions
being free Access to the earth
wiNs the
worlD
To exercise
wHat
to mE
thAt works

society's
Different from
goVernment

quAlities
we have oNly one mind
To exploit
very soon the nAtion-state
sonGs
most stubborn barriEr to the free circulation of the
uS
that wOrks so well we can run wild in it

For
We know
tHe
Is
that Confronts
all Human beings
tHat
oftEn-repeated option to make all the earth's people
liberty Considering it
globAl
Nature

slow chaNges
swOrn
Technology

 A
 iN san francisco in
 human soliDarity
 anarchiSm stands for
 eacH
 sOldier
 natUre
 seLf
 baseD

 meetiNg the free republic
the already-executed fifty-year critical path Of
 naTional
 of libErty
 fertility of the humaN soil

 Just change that
 hOw of all
 realitY

 Act
 locked iNto
 Discover
 the quAlity of
 real Social wealth

 Still retain
 gOvernments
 are nOt
 reality Never represents
 problem thAt
 uS and which the nearest future is
 Passing away and it is
 futurE it was a living
 nOw

 the regenerating Power of the new

 sociaL
 francE
 funCtion of the
 the most powerfuL of
 thEn
 this the frAud
 foRce and the
 poLitics
 democracY
 pictUre

the priNciple of authority that was never
aDmitting
arE succeeded by
haRmful
ground alloyS
wiTh
lArgely
oNe's self
at the crossroaDs

sysTem we now
to me anarcHism
order bAsed on
place undersTood and made useful

human naTure
mental Hospitals
bE freed from
Yet

hoW of all
does hIs actions
onLy
Liberty of each

way of riddiNg the
globAl
evoluTion
bUt
to eveRy
And
deveLop
a pLace that works
anarchY in
anarChist

simplE
differences Are
itS
this thE
criTical path
Of
repeaTed
weAlth an order that will
a King
an ordEr that will guarantee
hyPnotic
ultrA high
to exeRcise
socieTy

we can run wIld
 aNd it
 aS
 bUt
 beCome

 tHey
 anD
 thE
 changEs are
 accorDing to the individual
 cauSe

 fuTure is
 How to be one's self
 A
 wheTher

has acquIred all
nature'S way

perish Class
suppliEs

 An
 iS
 thE
 cannoT
 sO

african villaGes
 Is time for people to understand
 eVolution is
 thE full
 is abouT to put
 know-How of all humanity
 unitEd
in a position to Get rid
 brute fOrce and the principle of authority

instantaneous Voting on
to thE
act in natuRe
beiNg free
or huManity will
fEw
less thaN
The
So well we can
and itS
are nO
shackLes
anD
fInally
from thE '
fRom halting
the moSt '
in nAture

Now
he tolD
of Men can
periOds of
ruiNs
of thE
executed fiftY
no more be mAde
No less
absolisheD only in this
plAnt the '
and itS '
itS
seek tO
mOst highly
all heaveNly
cAn
that iS
And
doMinion of property
thAt are
Just
Of
fRee
phIlosophy
To
drop awaY

desires tastes and inclinatiOns
people be Freed

 Position
 of thE
 with Others
 exPression of
 heavenLy and
 onE
 in whiCh
 and othEr
 hAve
 Still
 Enjoy and
 aS
 from The
 slOw changes are
 aDmitting
 liberty Of
 infiniTy

 wHat we
 gaIned
 in motion becomeS
 a Tree

 anarcHism

 principlE
 Found and
 thRough
 dAd's airplane engine 1918 flew to pieces
 continUing
 Democracy

realize the increasing knoW
 will be abolisHed only
 retaIn one's own
 soCiety's
 oneness witH

 so that propErly
 aNd have
 thoSe
 quaLity of
 it As the unique
 eVolution as
 which hE cannot
 aS
 rePublic
 ovEr
 Of
 never rePresents
 heavenLy
 bE made

buWalda
socIety
externaL and
formaL

anything But
thE right technology

drAws now as far as he can
was for what i'd Been saying
Others finds there
buwaLda and
dIfferent
uS

anarcHists or
arE
over anD
Of
aNd organize a new
poLitics
under which intelligence dignitY and
lIfe to be lost at
No
liberTy in equality liberty
He can
by vIrtue of the
whether Something vital
Will be

pArt and the
moneY
development whiCh
metAls without
oN
only have all the big corPorations
voltagEs

One's
Poet of
not onLy
thosE
inhiBitions
wE
to make liFe
consideRing
intErnal
yEar
anD inclinations a man draws now as
oFten
in oneness with otheRs
was fOr
anarchisM
Said it wasn't
faiLure

A
something Vital will
and from thE
natuRe on
extension to infinitY

6

onE
allisHness

hAve only
allishnEss

yOu just
Nature on
therefore is simpLe

therefOre is simple

miNd
wE have only one
huMan nature
Is simple
that oNe
things raDically

base human naTure on
cHanging things radically

onE mind

yOu
miNd
wE
naturE on
juSt
tHe
Allishness
Radically
wE share
things radiCally

tHings
nAture
that oNe

sImple
oNe mind
you jusT
cHange one

sImple
oNly one mind the

change that one mind baSe
base human natuRe on
thAt
that one minD
allIshness

humAn nature
is simpLe
is simpLe
You
jusT
base Human
wE
Radically

wE share changing things

yOu just
Radically
havE

have only one mInd

Simple
mind baSe

one mInd
base huMan nature on
onLy
onE
onlY
On
hUman
natUre on
mind baSe

Therefore
things radiCally
tHerefore is
nAture
miNd

allishnEss

jusT
on allisHness
mind bAse
 Things

 yOu just
thiNgs
thE one
huMan nature

 sImple
chaNge
minD
 thAt one
thingS radically
onE

 cHanging
 jUst change
is siMple

we shAre
 oNe we

base humaN
 shAre
radically

 Therefore
yoU

things Radically
 wE have
 yOu
 miNd the one
we shAre

 onLy
have onLy
 sImple
baSe

 tHe
miNd
havE
 iS '
we Share

7

world-around metalS
tree tO me
within only a deCade by
In
wE
This

the

governments soldiers and moneY

plaNet
in Order
buT are
By

at

any momEnt we
physIcally
oNe

an averaGe
humAn
Possible
tuRning

Only
in this way Can
thE
Such
hiS
mAjority of

global electrical networKs
make lIfe
hoNest

Government
So that
advantagEs
noT only are not
honeSt

fruIt are
fraud which eNslaves

has hiMself
Of
of cenTral
allIshness
in Order
aN
But
sharE

physiCally
One
Mind

wE
alloyS
A
Networks change

whIch
huMan
hyPnotic
momEnt we have only
natuRal
waS

Of
aNd
which

hAs
infLuence to free us
more and more Passing away and it

centraL
hArmful
Chain of
agE for
natUre's
thiNgs in
be freeD

changE that
aRe
utilitieS
The
fOr
fOr
anD '
thAt
iN

Discover
is siMple

hAve '
Do this

most stubborn barriEr to the free

to the soUth
for governmentS notwithstanding
this that hE
From
of bUsiness

soon

as peopLe
juSt
immOral
flew To
ligHts
of mAn
The
hoNest man

yOu
Must not
not tAke
noThing
facT
it's arE
foR
Way of
tHe

Also for i am
as such and noT
to bE
we Are
anything Can
Happen

cease to gIve the
oN
they Drop away from
hIgh
for eVeryone
arrangIng things
arounD
still Undiscovered
them As such and
Liberty
arounD

arOund
to maintain thEir
moSt
patH of
commentIng on
in which a Self
of mAn
neCessary
Them

sImple
a Out of
exterNally
thiS

mEtals foods
upoN
rebeL
amerIca
remoVing
thE
thiNgs
easT

cHanging
morE and more

conTain the
One mind base
The
pArt in such
as peopLe
droP away
Is time
reCognized
was noT
hUman
Right

wE
discover diAlectrics
must Not
All
fRom
Cease to take
enligHtenment's no longer
externallY
vIrtue of
aNd

cleArly understand that
to Pieces
Life to be
by Any
the ' hypnotiC

wE have
realizable capabiliTy to exercise our
Honest
A
This
noW
Of
Recognized them
to maKe all the
moSt
anarchiSt
mOre

naturally Cease to take part
our often-repeated optIon
thEy
virTue
merelY
i'm
South
amerIca

techNology

saiD
wIll
goVernment
hImself
take part anD
sUch

yesterdAy's
worLd
saId it
thE
shoulD not enjoy and as soon

8

can Happen the problem that confronts us today

Idols will found and organize
that Purely formal liberty conceded measured and
never rePresents anything but
tO

the state

an eternaL
boundarY
To
libErty

tHe
All
indiVidual
Each

Liberty of each through the liberty of all

9★

by soLidarity
thE
fOr
yesTerday's
away

frOm the tree
sLow
impriSoned
liberTy

bOdies which

though the qualitY

IO

votiNg
like tO
liberTy
develOp
eveN now

Like to
dignitY and
tHe full development of
ones with us And
or indiVidual

wE know where
will hAve what we
beLieve that
each individuaL
can develop and grow

noT
to exploit american anarcHist
arE no restrictions i mean that
conceded measured and regulated By the state an
under whIch
kind of Government
regenerating soCiety
as such and nOt because they have
men aRe

i heartily accePt
individual nature sO that
aRe no restrictions
intellectuAl and moral

see iT acted
It as
fOrmal liberty

develop aNd
of otherS
anything But
liE
franCe
tO the south of
theM as
that will bE
The
wheRe we're
will whAtever

what we fiNally
which alSo
develop aNd under which
A
buT the
seek to do Is
Out of
the ruiNs of
And the
truLy
undiscovered discover diAlectrics for ultra high voltages global electrical . . .

coNsists in the full
crossroaDs in
am a fanaTic lover of
dAd's
that worKs so
in Equality
Not
Accept
voLtages
engine 1918 fLew

sTill
society mental Hospitals localization of a
likE
oF man
Own individual
anything but the intellectualized expRession of that force

 east Manhattan
 accEpt the
 that woRks so
 foUnd
 So differences
 thAt works so well we can run
 instantaneous votinG
 upOn
 an eternaL
 more rapiDly
 A

 Name
 take the maD
 electrOnic democracy
 liberTy of
 or Human
 yEt
 Rapidly
 haviNg
 in this that hE
 throuGh
 sOlely
 The
 faIlure
 they hAve
 Brute
 soLidarity
 thE kind of
 An
 of all the powerS
 of human Solidarity
 and thE expression of
 pieces before iT
 Should

 overthroWn
 refreshIng
 Take
 Happiness of men
 solidariTy
 of Human solidarity
 purEly
 liberty triuMphing

 that government is Best which governs least and i
 to pieces before it left the groUnd alloys needed
 The

iT as
manHattan
fEw founded on
Yet to exploit

even now He told me
formAl liberty
or indiVidual
uniquE condition under which
he hAs
each Liberty
iS best which
differences are refreshing nOthing
yet to expLoit
considEring it as
Formal
dialecTrics for
of Authority that was never anything but
pureLy
Like
digniTy and
mental Hospitals localization of a
statE
that Will be
refreshing nOthing to do with possessions

libeRty in
Liberty by
them as such anD not
we've
earthly idolS will
develoP
thE
bOundary before the liberty of others
which in reality never rePresents anything
individuaL

accEpt the motto that government is best which governs
in this that he obeys naturaL laws because he has himself
left the grOund

the powers material intelleCtual and moral that are latent
properly speaKing
rEstrictions than
that consists in the full Development of
lover of lIberty

lie aNd which ' in
buT the

man can develOp and grow
yeT
far from Halting
dEmocracy
externally Imposed upon him
befoRe it left the
votiNg on
And all
lefT
upon hIm by any
there are nO
aNd its
wild in it i Am a
governs Least and i should like to see it
to exPloit

divinE or
this that he obeys Natural
alloyS needed to contain the
neW world that of human
expressIon
accepT

Happiness of men
conTain
of Human
the sOuth of france
of all churcheS and all
in Equality
the liberty of maN
cArried
liberTy
we fInally seek
Of the
aNd ' the
So

each liBerty that recognizes
by soLidarity liberty in equality liberty
cOntain the power
aCted up to more rapidly
taKe
each lIberty
aNd
orGanize a new world

 lefT
 upon Him by
 considEring it as
 prepared For it that
 Laws because he has himself
 create an envirOnment that
 and Which
 dO with
 From
 america middLe
 mental hospItals localization
 oF
 that libErty of each individual

 liBerty which after having overthrown
 the powers materiaL intellectual and
 Of
 and mOral that are
 anD
 aM
 of francE
 of The '
 wAs never
 that pureLy
 refreShing

 the laWs of our own
 possessIons/power i
 leasT and
 of Human
 Of all
 Undiscovered discover
 hospiTals

 they Will
 of eacH
 on the ruIns of all

dignity and the happiness of man Can develop and grow
liberty tHat recognizes no other
Which in
high voltagEs
whiCh in
lAws of our
grow Not that purely formal
them as such aNd
latent faculties Of each
The
which faR from
it actEd
At
the onLy
that consIsts in
slavEry
illimiTable
upon Him
foundEd on the slavery of everyone

of all lIberty
meN are prepared for it that
Consists in the full
of ouR own individual
middlE

chAnge
oneS
name lIberty that
of our owN individual
Government
that worKs so well we
fouNded
Out of central america
We '
tHat he '
far frOm
feW

sOlely in this that he obeys natural laws
that Force liberty
which After having overthrown
Like to see
high voLtages global electrical networks

Himself recognized them as

laws becaUse he has

Me they '

he hAs himself

it fiNally

others fInds

The

onlY liberty truly

instantaneous Voting on

rEality

Recognizes no other

which theY will have what

externally impoSed

which gOverns least

than thOse

i meaN

of human solidariTy on

governs least and i sHould

forcE

fiNds there its

hAve

before iT

governs least and I

dO is

of that force liberty which after haviNg overthrown all heavenly and earthly

Such and

governmenT is best which governs

wild in it i Am a '

of cenTral

slavEry of

Speaking

happiness Of men

our own indiVidual

south of francE dad's

natuRal laws

thE

governs not at all and when men are prepared for It that will be the kind of

happiness of men can develop and Grow

wild iN

of oThers

before It

mEntal

itS extension to infinity

Where we're
carrIed out it
Liberty by
Liberty truly
us and we know wHere
which fAr from
our own indiVidual
principlE of
i am a fanaTic
discOver dialectrics for ultra high voltages

By
not at all and whEn
thEm as
to this which aLso
of authorIty that was
the naMe
governs least and I should like to see it
still uNdiscovered
not becAuse
kind of governmenT which
amErican anarchist 1900
aDmitting failure retired
sO well we can
high voltages global electRical networks
in reality never represents anytHing
the intellecUtalized expression of that force liberty which
liberty that consists in the full developMent of
possessions/power i heArtily accept the motto that
are for it that will be the kiNd of government
fInally
over bruTe
resource we've Yet to exploit

american
Where

we're
the happIness of men can
eLectronic democracy instantaneous voting
and moraL
hosPitals localization of a
told mE they sit at
it left the gRound alloys needed to
In it i am a fanatic
extenSion to infinity
outlined for us by tHe laws of our own individual nature

II

Assets with
priviLeges and
need To
changEs which
of Ridding the
eArs we need
carried ouT

lIberty that
fOr '
aN
as a majOrity of
to do this the Fraud
riGht
of innumerabLe
Of people ceases to do this
conceded measured and regulated By the '
And have a
oneness with others to feeL

future iS
their Own
to this whiCh also
of eternIty of
futurE is
of The united
new philosophY

noT be overlooked in
setting off a cHain of
oveR and
liberty by sOlidarity liberty in
as well as the pUblic's revolution

is

aGe for
people pHysically and
powErs
a sociaL
agE
by Calling on
The
to me anaRchism was
Of
is No
rIght
a Chain of
government iS

of privilegeS and
capability tO exercise our
naTure of
refresHing
destruction of privileges And monopolies
already-execuTed
Will
sOuth
fRee
nationaL
accorDing to
We now have
on allIshness

communaL
is the constitution of innumerabLe
liberty of each throuGh the liberty
Of communes of
aRe
Often
Us

restraiNt of government
seeD
Be
the new societY
theM
fErtility
Am
bouNdary before
national bodieS

develOpment which
Finds there its
sUch deeds
goverNs least
wIll found
real social wealTh an
problEm
anD freedom
electrIcal
wishes aNd
wiThin
bE freed
buwaLda for
be abLe
soon the natIon
sonGs of
thEm but
chaiN
of whiCh
will havE to be
gRoupings
And
hypnoTic influence
cannot and sHould
bE
states aRmy
uniTed
wHole of
our own individuAl
of people Near and far

the united states of america out of Business

a free man wins the victorY

 got theM global
 stands for thE
 now hAve
 withiN
 and itS
 abOut by a desire
 nearest Future is to solve
 anD
 amerIca
 to solVe
 flow of lIfeblood
 aS soon as
 so dIfferences are
 anarchists or reVolutionists
 it is timE for
 anarchIst
 aNd which in
 This which
 changEs are
 aboLished
 is to soLve
 engIne
 in reality it is enouGh if
 to thE
 aNd thereby setting off a
 Cannot
 libEration of the human mind

 dad's airPlane engine 1918 flew
 abOut
 rapidLy and
 whIch
 loyalTy
 perIods of violent
 Change
 one year thankS
 to opEn
 through information adviCe and example

 rebel the wOrld over
 the New
 peOple be freed
 anarchisM stands for
 engIne
 within only a deCade
 problemS connected with sounds were insufficient

12★

cAnnot
solelY in this
thE
And
fRee

songs oF
able whole-heaRtedly
gOing

a Man draws now as
becoMe
wOrld
admittiNg failure

Develop
stAnding
curiositY

13★

Curiosity
About
silence in order to oPen
the crossroAds in
on them to provide through direCt and
representatIve
broughT about
armY
on them to provide through direct And
localization of a resoUrce we've yet to exploit

serve to make known anD
and economIcally
own charactEristic qualities

actioN for their own futures revolution
of the masses by Calling on
thE whole of social life and raise
the Ground
ceAse to take part in such deeds
remoVing
sElf and yet in oneness
wisHes and tastes of all

marvelous structure of realIty it is enough if one tries

property liberation froM the

it waS a living influence

To

prepAre them

Not because they have

retireD to

problems connected wIth

every dauNtless rebel the world over and

throuGh

therefOre is simple

the creation of new liVing institutions new groupings new

Are '

will be The '

If

to prOvide

eveN now

soCiety

dO whatever

is More and

hiM

onE we share

the free groupiNg of individuals for

is The

most hIghly

characeristic qualities aNarchism then really stands for

not only have all the biG '

Of '

aNd as '

of jusTice of

sHould

become transnatIonal and taken all the former united

the deStruction

the liberty oF man

be done is to plant the seeds of thoUght whether something

of reaLity it is enough if one tries

hospitaLs

is thE '

foR '

that exiSt

goldmAn's lecture attracted
pIeces
for a social orDer based on the
problem that confronts us today and whIch
new groupings new social relaTionships it is the destruction of
Which we
of Anyone no government no
South
iNterests of people near and far and
public's
changes revoluTions are as
the utilities we are merely Facilitating
Of
ameRican anarchist 1900
by calling on theM to
arE now
hIs life

yesterday's sovereignties
the veneration of governMents
pOet
caN
exist among the peopLe revolution is the forming and disbanding of
the mYsteries of eternity of life of
tAke
global electrical Networks
brought About a desire for brotherhood by
the free groupings of indiViduals for
works sociEty's individualized not songs of
and faR '
of A resource we've yet to exploit

technoloGy

living institutions nEw groupings new social relationships

foods incoMe energy supplies

ideAs

oNes

acquIred

abouT by

ones With us

one's self And yet in

iS how to be one's

communes oF

On

cuRiosity

netWorks

tHe

tAken all

former uniTed states of

anarchIsm then really

france dad's

anD conscious action for their own futures

But

lifE to

national bodiEs which without

aN

theSe

cArried out

as You are when you're

Is the free

oN them to prove through direct

destruction of privileGes and monopolies

of realiTy it is

regenerating society mental Hospitals localization of

dEmocracy instantaneous voting

for their own Futures revolution is the

institutions in which A self

of a resourCe

of life according To

enlIven

oTher

are when you're

people be freed from Slavery

dePends largely

stOp

power Serve to make known and coordinate
locked into their 150 national penS
for one year thanks to the regeneratIng power of the new philosophy
revolution is the free federation Brought about
that externaL and from
of rEgions
realize The increasing
new sOcial relationships it is the
williaM
people As people ripen they drop
wishes and tastes of all Kinds that
as thE autonomy of groups of communes of '
of representative districts communaL
vIllages regenerating society
sit at the crossroads in aFrican
thE whole of
turning on/off the lights drinking wAter the important thing
and people are now in a poSition to get rid of the one
within only a decade by virtUe of the already
Communal regional national bodies
one mind the one we share Changing things radically
of thE new
alSo for i am the
pieceS
the hypnotic inFluence
grOups of communes of
needs of pRoduction and
told mE they sit at the crossroads in african
seeds of though whether something Vital will
martialEd buwalda and
ties it is the autonomy of gRoups of communes of regions revolution
to be lost at anY
cOurt
is Not to stop
poEt

aN
Of
liberaTion
world'S
 frOm the shackles

baNkruptcy
orGanization of all
economicS

the tOtal
was For
eternaL
 sOvereignties and have
processes so that anYthing
for governments notwithstAnding
future is to soLve is how
iT as
the onlY liberty truly
liberty thAt recognizes no other restrictions than
the fact it's possibLe
Of
aNd
powErs

And
oR
fEw

an anarchisT
eacH
Evolution

Solidarity
on thEm
people Be freed
rUn wild
whaT we
Saying
thOse
maN
Grow
honeSt
in Order to open
away From the tree
wIthout
oN the
thoSe
new groUpings new
libeRty
libeRty triumphing

monopoliEs
of government

anarChism
philosophy

The
whIch they will have
nO sheep the liberty of
the ruiNs of
cAuse

Lecture
on the Slavery
nOt at all and when men are
Free
Of
away fRom
goIng
chAnges
iMprisoned him
To
How of all
sociEty
Slavery
Wasn't
happiness Of men

attRacted a
of the Name
more and more Passing away
sO
thE
privaTe
individual dOes
desire FoI
rEtain one's own
haVing
to makE
fRee access to the
influence theY employ
for brotherhooD
hAve
each individUal
beiNg a
liberTy

soLidarity on
rEvolution
waS never anything but
all humanity very Soon

a boundaRy
thE nature of
regulated By
no rEstrictions
the pubLic's
inTelligence

individual does His actions
unitEd
in this Way
tO the
aRe
the Liberty of others
anD
Of
reVolution is
to thE
fRee
thAt's the
Negotiable
golD
So
inTelligence
And not
King

through intErnational bankruptcy
Social realization

no otHer
In which
So that
peopLe ceases to do
government whIch they '
oF
thE '
This which
life

accOrding to
them But
a procEss
a sociaL
Or human collective or individual we'll
them and Succeed

The
ideAs wishes and
governmenT
we hAve
ruN wild in
libertY

theM but they
One we '
the Most
thE

aNd
To change the nature of music

15

 condiTions
 Hypnotic
 arE harmful and most
brotherhood of freedom whIch
brotherhood of freedoM
 is the new sPirit
 freed frOm
 people be f Reed from slavery

 hypnoTic influence they employ to
 conditions of the mAsses by
 beiNg a process
 influence They
 Take part in
free groupings based on ideas wisHes and tastes of all
 Is
 aNd example electronic
 aGe for
 the destructIon of
 action for their own futureS
 aNd
 prOvide
 as well as The
 The fraud which enslaves

Only are

iS

of The masses by calling

in them in their Own interest as well as

the hyPnotic

and defense revolUtion is

of thE

autonomy of groupS of communes of regions

auTonomy of groups of communes of

hIghly

slavery sOciety

it is the New

governments soldIers

eNjoy and as soon as people clearly understand

that Governments not only are

destruCtion

withoUt having

but aRe harmful and

Is

gOvernment

imperSonal

In

noT

free federation brought about bY a desire

by tHose who work in them

it is the Autonomy of

Such deeds that

In

by individual and collecTive

people will be aboliShed

thrOugh direct and conscious action for their

position is more and more passing aWay

advice aNd example

is the oRganization of all public

dEstruction of

A place that

reSpecting

Of

freedom which must reNew the whole

people ceases to do this the Fraud which enslaves

thrOugh

and faR and which act through

wishEs and tastes of all

must renew the whole of socIal life and

money and aS soon as a

picTure

whIch without

should Not enjoy and as soon as people clearly

people near and far and which act throuGh

understand that they will naturally cease tO take part

iN which a

futurEs revolution is

raise the moral level and material Conditions of the

thAt works society's

public services by those who work iN them

oNly are

justice Of

moral level and maTerial conditions of

eacH individual

of rEgions

and raise the moraL level and material conditions of the masses

his actions enliven the total Picture anarchy in a place that works

By a desire for brotherhood by

do this the fraUd which enslaves people will be abolished

They will

By

as wEll as the

Is

all coercive ties it is the autoNomy of groups of communes of regions revolution

to tAke part in such deeds that is

anarchy in a place that Works

rEvolution is the creation of

the total picture anarchy in a place that Works society's individualized

tHis

to givE

iN a place

it is time for people to understand tHat

rEvolution is

soCiety

that wOrks

New living

necessary buT

what Each individual does his actions

exist aMong the

new social relationshiPs it is the

revoLution is the constitution of

of people ceAses

socieTy's

nEw

iS more and more passing away

of all coercive Ties it is

cannot and sHould not

of all kinds that Exist

it is tiMe for people to understand that

without having anY

revolution iS '

revoluTion is

will bE abolished only in this way can people be

and faR and

of people ceaes to do thIs

anarchy in a placE that

revolution iS

their Own

people ceases to do this the Fraud which
of anyonE
will be abolished only in This way
honEst man cannot and should not enjoy and
fRom slavery
it is the New
brotherhood of freedom whIch
of jusTice of brotherhood of freedom which must
emploY
passing away and it is time fOr people to understand that governments
productions and deFense
to do this the fraud which ensLaves
own Interest as well as the public's revolution is
disbanding oF thousands
as thE public's
actiOn
regions revolution is the Free
people revoluTion is
eacH individual
powEr serve to
cannot and Must not
society not being A
goveRnments not only are not
indiVidual and
among thE
no matter what each individuaL
demOcracy
of innUmerable free
the conStitution of innumerable free
not enjoy and aS soon as people clearly
This way can people be
can people be fReed from slavery society

governments not only are not necessary bUt are
bodies whiCh
They
are harmfUl and most highly
in a place that woRks
spirit of justicE
will be abOlished

only in this way can people be

liFe and

place undeRstood and

sEts in motion becomes

thAt governments not

that governments not onLy are not necessary but are harmful

and raIse

parT of

electronic democracY

hIs

seTs

not beIng a

brotherhood of freedom which muSt

position is morE

Necessary but are harmful and

interests by the needs Of

new social relationships it is the destrUction of

and must not take part and tHe advantages of

Is the autonomy

not only are not necessary but are harmFul and

sOcial life

should Not

thEy employ

do This the

not take paRt and the advantages of

Is

by calling on thEm to provide through direct

but are harmful and moSt highly

justice of brotherhood of freedoM which must

thE autonomy of

the oRganization of all public

wishEs and tastes

be aboLished

actions enliven the total picture anarchY in

voTing

freedOm

interests of people near and far and whiCh act

sOcial life and raise the

passing away and it is tiMe

to maintain their Position

democRacy
 thE desires and interests of people near and far and
 deeds tHat is
 bodiEs
 liviNg institutions new groupings new
 innumerable free groupings baseD on
 conscious Action for their own futures
 and as soon as peopLe clearly understand that
 bodIes
 forming and disbanding of Thousands of
 which he cannoT and
 the creation of new Living institutions
 groupings nEw
 public services by thOse who work in them
 through direct and conscious action For
 revoluTion is
 sucH deeds that
 enlIven the total picture anarchy in a
 well aS the public's revolution is the
 passing away and it is tiMe for people to understand that
 influence theY employ to maintain their
 new Social
 serve To
 rEgions
 distRict communal regional national bodies
 in this waY can
 dEstruction of all
 no matter what each indiVidual
 voting on thE
 Revolution is the organization
 that theY will naturally cease to take part in such
 wishes anD
 their position is more And more passing
 emploY to
 coNscious action
 but arE harmful and most highly immoral

 the creation of new liVing institutions
 voting on thE
 is the foRming and disbanding of thousands
 of new Living
 which he cannOt and
 action for their own futureS
 anarchy in a placE

public's revolution is the destruction of All coercive ties it is
public's revolution is tHe
give the gOvernments
the pubLic's revolution is the destruction of all
organization of all public services bY those who work in them in their own
power serve to make known and Coordinate the desires and interests of people
of regions revolUtion is the
which act thRough
that exIst
and must nOt take part and the
way can people be freed from Slavery
the free federatIon
broughT about
which enslaves people will be abolished onlY in this way can people be freed

16

dad's airPlane engine 1918 flew to
centRal
flew to pIeces before it left the ground

reVolutionists
chAnge
human soil Though
rEvolutionists
airPlane flew to
ameRica middle east manhattan
undiscOvered
out of central america middle eaSt manhattan american anarchist 1900
that can be done is to Plant
1918 flEw
still undisCovered
souTh

seed must nOt be
leFt
to plant thE
uNdiscovered
overLooked
faIlure
larGely
to do witH
someThing vital will
bE
uNdiscovered
adMitting
thE
caN no more be made
To contain the power
dialectricS
caN

the sOuth
the quaLity
fOr
alloys Needed
thouGh
dad's airplanE engine 1918 flew to pieces

laRgely
Something
intellectUal
leFt
the quality oF the
engIne

all that Can be done
to do wIth
lEft the
chaNge

wheTher
society so differeNces are refreshing
sO differences are refreshing
planT the seeds of
states oUt of central america middle
are refreShing
uniTed
muSt not
bE
america middLe east manhattan
discover dialectrics For
all that can Be done is
the hUman soil
The
pieceS
can nO more be made
Can no more be made than
possessIons/power
or revolutionists cAn no more be made than
america middLe east manhattan
possessions/poweR

anarchists
must not bE overlooked
so differences Are refreshing nothing to do with
not be overLooked

It left
high voltAges global
human soil Though the
vItal will
netwOrks
the iNtellectual seed

17★

<div align="center">

witHout

sociEty's

crossroad iN

ciRculation

bY

seeD

plAce understood and made

eVen now

to exploIt

can no more be maDe

musT

His

nO

wateR

madE

villAges regenerating

pUrpose

</div>

18★

everyone i Mean
accordIng to individual desires tastes and
enjoy and as soon as people Clearly understand
nature and freedom a free man wins tHe victory
eternAl

anything but thE
nationaL
By
thousAnds of representatives

anarchy in a place that worKs

the intellectUal seed must
Not a mere theory for a
new socIety

their owN

19

conscious Action for
Mystery

prepAred for it
of eterNity of life of the marvelous structure of reality it is
the liberation of the human boDy

has himself Recognized
destructive bArriers that separate man from man

they Will have not
help but be in awe when he contemplateS the mysteries of
wheN he
cOmmunes of regions revolution
and When men
coordinAte
nature and freedom

a free man winS
enjoyment oF the '
thAt
in theiR
pArt and
electrical networkS
in Him
mEans
anarChism
nAture
regioNs
tO more
aNd
sTill
anarcHism
soldiErs
the kiNd of
them As
for The
aUdience
contemplates the mysteRies of
eArs

we need
high voLtages
oF restraint
Of
desiRes

aCt through
tiEs
of musIc we
dauNtless
brougHt
new groupIngs

theM
respecTing
He
Are
The
mInd
problemS
differeNt
Of
them anD
creatIon
leFt

it is the new spirit oF
thE
distRict
of thE masses by
based oN
To provide
but are harmFul and most
our eaRs we need
tO exist and act in nature and
can no More be
possessions/poWer

i
nature on allisHness

the frAud
prospecT of
amerIcan
wheTher
for their oWn
government Is
for uLtra high
sociaL wealth
puBlic
thEy

It
a maN draws now as
social realizaTion
world over and stakes His
arE
aN
thEory
to make knoWn
aS
exist amOng the people
united intelligenCe rather than
government Is

wE
whaTever
enjoY
froM
nEw
fRom
thEy
to be abLe
verY
anarChist
life Of the '
of sileNce in
direcT and
Is '
aNd
are sUcceeded by
seek to do Is
aNd inclinations
larGely on
will naTurally
nO
madE than
In which a
power Serve
of governmenT
flew to pieces before it left the ground

Alloys

awe wheN he contemplates the mysteries

is to plant the seeDs of thought whether something

things in order

thAt's the

serviCes by

we have only one mind The

real socIal wealth

that they will Naturally

coNceive of

fAr as he can on the

wheTher something vital will develop depends largely on

advantages of which he cannot and mUst not take

in them in theiR own

and yEt in oneness with others to feel deeply with

the nAture of

the revolutioN is the creation of new living institutions

more rapiDly and systematically

oF the masses

the veneRation for

thEm

to Exist

anD it is time

sOlve is how

we are

Merely

And

oF

libeRty

thE

of global sociEty through electronics so that world will go round by

the nature of Music

we

things in order thAt's the

beiNg free access to the earth

one's oWn

Is '

aNd

order baSed on

parT in

us to wHat

sociEty

is to solVe

a majorIty
purpose of produCing real social
governmenT is best which
dO this the
anaRchist
as You
maintain thEir
nature and freedom a free man winS

Thing is not to stop
And freedom
Be
for the purpose of producing reaL
processes so that anythIng
tellS us to

problems of governments are not inclusive enougH

matErial
revolution iS
whaT we finally seek
to take part in sucH
fErtility
as he caN
from thE
Way can people be
a holy curioSity private
life and raise the mOral level and material
of reality it is enough if one tries merely to Comprehend a
as well as the publIc's
only onE mind

mind from The '
imposed upon him bY any extrinsic will whatever

20

Before
the groUnd
hypnotiC
maKe life

Manhattan the age for
real socIal wealth
away aNd it

for ultra high voltageS global
liberTy
sociEty
pRoblem
liberty oF each
by virtUe of
deepLy with
buwaLda for daring to

brutE
laws of ouR own individual nature

Library of Congress Cataloging-in-Publication Data

Cage, John

 Anarchy / John Cage. — 1st Wesleyan ed.

 p. cm.

 ISBN 0-8195-6466-4 (cloth : alk. paper)

 I. Title.

PS3505 .A2533 A8 2001

811'.54—dc21 00-066819